Pablo Picasso

D0265868

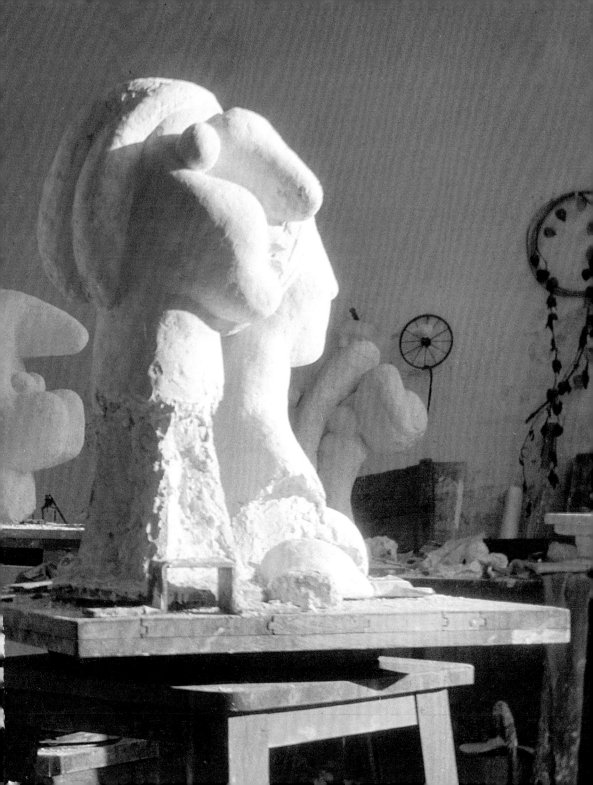

Pablo Picasso

Silvia Loreti

Tate Introductions
Tate Publishing

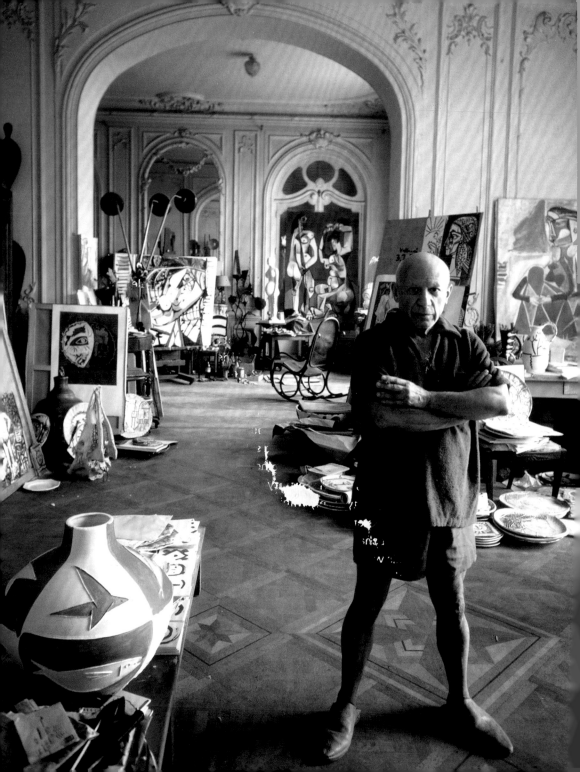

1. Pablo Picasso in his
studio at La Californie,
Cannes, 1956
Photograph by Arnold
Newman

The artist is a receptacle for emotions that come from all over the place: from the sky, from the earth, from a scrap of paper, from a passing shape, from a spider's web … We must pick out what is good for us where we can find it – except our own work. I have a horror of copying myself. But I have no hesitation, if one shows me a box of old drawings, to take from them anything I want.[1]

With these words from 1935, Pablo Picasso revealed, at fifty-four, the secret behind his uniquely varied body of work: he explained the constant shifts by declaring his democratic, if opportunistic approach to stimuli. Seemingly insignificant elements from the natural world are only a few of the many different inspirations feeding into his constant quest for self-renewal. Picasso freely reinterpreted his sources – from the old masters to modern artists, from traditional and popular culture to personal and collective memories – so that their presence in his work is never transparent but always evocative and often subversive. He returned cyclically and selectively to his own work, adjusting it according to his changing modes of expression. In engaging in a dialogue with history, he placed his oeuvre, for all its radical modernity, firmly within the European tradition, while eschewing the consistency expected of masters and the adherence to the '-isms' that characterise modern art. He was both impulsive and rigorous in his working method, often drafting numerous preparatory sketches that trace his creative process. The human figure and its immediate surroundings remained his most-favoured subjects. The day-by-day aspect of Picasso's art, his attachment to figuration and the careful recording of his activities, as well as the attention that his private life attracted throughout his career, have made it impossible to discuss his work without taking his biography into account. It is, however, important to remember that his work is a translation of reality that seizes inspiration 'where we can find it'.

Beginnings in *fin-de-siècle* Spain

Although he spent most of his life in France, Picasso never forgot
the experiences and teachings of his Spanish upbringing. He was
born Pablo Ruiz Picasso in Málaga on 25 October 1881 and, as an
Andalusian, he would enjoy attending bullfights all his life. The
first child and only son of José Ruiz Blasco – a painter and teacher
specialising in genre scenes of birds – and his wife Maria Picasso
y López, Picasso had two sisters, the younger of whom died when
he was thirteen. Growing up as the repository of his father's artistic
ambitions, as a young boy Picasso made paper cut-outs of animals,
in imitation of Don José's pigeon maquettes (fig.2).[2] Picasso's formal
teaching began in 1892 in the town of La Coruña, where his father
taught in the local art school. Among a varied body of studies, he
produced meticulous academic drawings after textbook lithographs
of ancient plaster casts (fig.21).[3] In 1895 Picasso enrolled at the La
Llotja School of Fine Arts in Barcelona, and finally in 1897 he was
admitted to Spain's most prestigious fine art institution, the Royal
Academy of Fine Arts of San Fernando, Madrid. Academic training
exposed him to a vast array of Western art – from ancient statuary
to the Italian Renaissance, from the 'Golden Age' of seventeenth-
century Spanish painting to the new realist tradition – which he could
study in reproduction or at the Prado Museum.[4] The Academy also
taught him the importance of drawing, which he would often use
as an independent medium, and to conceive his compositions and
figures in terms of well-known works of art. *Science and Charity* 1897,
a religious genre scene that Picasso painted while in Madrid, gained

2. *Dove* c.1890
Paper cut-out
5 × 8.5
Museu Picasso,
Barcelona

him various honours.[5] To his father's regret, however, he became frustrated with his teachers and, in 1898, left academic studies forever. Returning to Barcelona, Picasso joined the city's group of bohemian artists known as Els Quatre Gats (The Four Cats) after the (still standing) café where they would gather. These artists worked in the style of modernisme, a nationalist Catalan art movement influenced by Northern European symbolism. In particular, the modernistas looked to Paris as their benchmark – and it was to Paris that, aged nineteen, Picasso made his first international journey in October 1900.

Belle époque Paris and coming of age

The occasion for the trip was the inclusion of one of his paintings, *Last Moments* 1899, in the contemporary art section of the 1900 World's Fair. During his stay in Paris, accompanied by the poet Carles Casagemas, Picasso sojourned in Montmartre, an artists' neighbourhood that housed a large Catalan community. The area's shady nightlife provided a vivid stimulus, and publications featuring reproductions of Henri de Toulouse-Lautrec's recent lithographs and paintings of famous cabarets were also popular among the modernistas. The atmosphere in Picasso's *Moulin de la Galette* 1900 is indebted to Lautrec (fig.22). Its composition, however, mirrors (and perverts) Pierre-Auguste Renoir's earlier *Dance at Le Moulin de la Galette* 1876, an impressionist painting made when the establishment was still an open-air afternoon attraction.[6]

After spending some months back in Spain, Picasso returned to Paris in June 1901 for the opening of his exhibition in the gallery of Ambroise Vollard, the leading dealer of the post-impressionists. The show was not a commercial success, but it revealed the extent of Picasso's chameleon-like abilities: he had rapidly assimilated all the recent trends in French painting and applied them to matching subjects.[7] It is at this point that he dropped Ruiz from his signature and became, simply 'Picasso'. Meanwhile, the suicide of Casagemas and the hardship of life in Paris (underlined by his own poor finances and a deliberate visit to the female hospital and prison of Saint-Lazare) revealed the darker sides of the *ville lumière* and provided the catalysts for what is known as Picasso's blue period. His *Self-Portrait* 1901 shows him embracing symbolism fully by evoking a timeless

atmosphere and literally immersing himself in a darker palette to convey his sense of isolation, melancholy and destitution (fig.23).

Picasso spent the years 1902–4 mostly in Barcelona, where he struggled to make ends meet, sympathised with anarchists, made his first attempt at modelling sculpture, saw displays of medieval Catalan art, and continued his studies of the work of the Spanish Renaissance artist El Greco, the old master who influenced him perhaps more than any other during his formative years.[8] In Barcelona he painted the enigmatic La Vie 1903, the grandest of his blue period works (fig.24). Out of necessity, he reused the canvas of Last Moments, the painting that had brought him and Casagemas to Paris. Indeed La Vie appears to be an allegory of Picasso's coming of age, both emotional and artistic, in which the image of Casagemas stands for that watershed moment propelled by the experience of Paris.

In April 1904 Picasso settled in Paris permanently. He moved into a studio in Montmartre's Bateau-Lavoir, an international artists' colony, and soon began a relationship with Fernande Olivier, an artists' model. The change of environment brought a shift in mood and subjects

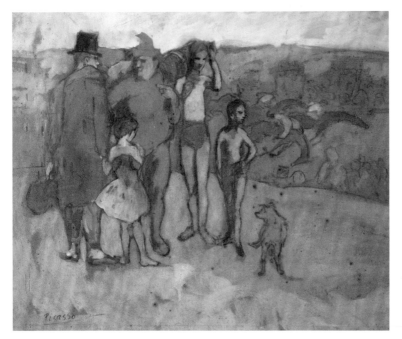

3. *Saltimbanque Family*
1905
Gouache and charcoal on board
51.2 × 61.2
Pushkin Museum of Fine Art, Moscow

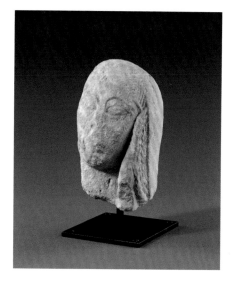

4. *Head of a Woman*
Iberian, Spain, 4th–3rd
century BCE
Limestone
19.8 × 20.5 × 12
Musée du Louvre, Paris

within his work. In her memoirs, Olivier tells of how Picasso enjoyed going to the nearby circus and spending time with the clowns and acrobats after the shows.[9] He began to conflate circus characters with the itinerant figures of the commedia dell'arte, a form of street theatre dating back to the Middle Ages, and to associate himself with one of them, the inconstant and mischievous Harlequin. A 1905 exhibition in Paris inaugurated Picasso's so-called rose period and marked the beginning of a deep friendship with the poet Guillaume Apollinaire, who reviewed the show enthusiastically. *Family of Saltimbanques* 1905, the masterpiece of this period, has been seen as a biographical allegory of Picasso's Montmartre entourage, including Olivier and Apollinaire, with Picasso himself as Harlequin (fig.25). However, its preparatory sketches reveal that he gradually moved away from anecdotal descriptions to convey a dream-like atmosphere that draws on distant and diverse moments of Western visual imagery (fig.3).

Around this time Picasso began to study the Louvre's collections of Mediterranean antiquities, which had broadened to include pre-classical archaeology. He became fascinated with Iberian sculpture from Andalusia, at that point considered to be both European and exotic, for it reflected his status as a foreigner in France and the supposed 'primitive' character of modern Spain. This connection was reinforced by a summer spent in the Spanish Pyrenees, where he

carved woods in the primitivist style of the artist Paul Gauguin. Upon his return to Paris, Picasso painted his self-portrait in Iberian-style.[10] Whether he or Apollinaire actually commissioned the thefts remains a moot point, but when two Iberian heads were stolen from the Louvre in March 1907, they immediately entered Picasso's collection (fig.4).[11]

At this time, Picasso began work on *Les Demoiselles d'Avignon*, his largest canvas to date (fig.26). Its intense gestation can be followed through numerous sketches which show that the composition began as an allegorical scene of two men visiting a brothel (fig.5). Picasso continued to experiment on the canvas. First, he simplified the scene into five Iberian-style nudes that referenced the Western tradition, from ancient Venuses to Paul Cézanne's recent *Bathers* (*Les Grandes Baigneuses*) c.1894–1905.[12] Then, he 'primitivised' the three lateral figures by referencing the art of ancient Egypt, Gauguin, and African and Oceanic masks. He had recently visited Paris's ethnographical museum, driven by the contemporary fascination of fellow artists with 'tribal' sculpture. The association between primitivism and sexuality in *Les Demoiselles d'Avignon* shocked even Picasso's bohemian friends and the painting remained hidden in his studio for almost ten years. However, by 1916, when the work was first exhibited in the gallery of

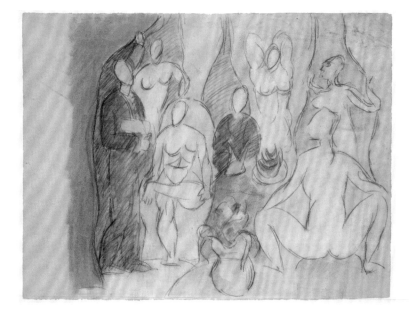

5. Study for *Les Demoiselles d'Avignon* 1907
Graphite and crayon on paper
47.7 × 63.5
Kunstmuseum Basel

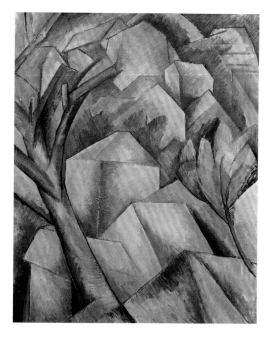

6. Georges Braque
Houses at L'Estaque 1908
Oil paint on canvas
73 × 60
Kunstmuseum Bern

the fashion designer Paul Poiret, primitivism had become stylish. A successful auction of blue and rose period paintings in 1914 signalled that Picasso's maturity coincided with, and indeed advanced, Paris's position as the current centre of the international art world.[13]

Cubism: The invention of a modern visual language

It took even less time for fellow avant-garde artists and modern art enthusiasts to fall for cubism, the style that Picasso created and developed in close collaboration with Georges Braque. In November 1908, Braque, who had been an apprentice painter-decorator, exhibited landscapes that one critic labelled as 'cubes' (fig.6). They were shown in the gallery of the young German dealer Daniel-Henry Kahnweiler, who had also began to collect Picasso's work and was to become his first contract agent.[14] Soon after, Picasso transformed a commedia dell'arte Last Supper scene centred around Harlequin into the large *Bread and Fruit Dish on a Table* 1908–9 (fig.27).[15] This still life (a genre little explored by Picasso up to this juncture) bears witness to the influence of Braque via both artists' common admiration for Cézanne.

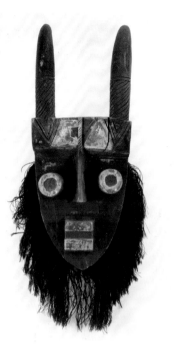

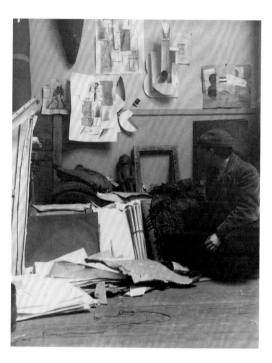

The following summer, while on holiday in Catalonia with Olivier, Picasso decomposed her figure into geometric facets (fig.28). Back in Paris, he drew on the sculptural qualities of these paintings by modelling a head of Olivier in clay.[16] A year later, Vollard acquired the work and had it cast in plaster and bronze.[17] This phase in Picasso's and Braque's work is known as analytical cubism, for their increasingly monochrome paintings – called 'hermetic' at their most abstract – have been interpreted as philosophical investigations into the essence of representation.[18]

To counter these abstract tendencies, the artists introduced easily recognisable signs such as numbers, musical notations, stylised body parts and commonly used typefaces that underline cubism's incorporation of contemporary culture in its creation of a thoroughly modern visual language. In 'Ma Jolie' 1911–12, which marks the entrance into Picasso's life of a new mistress, Eva Gouel, the inscription on the painting is a reference to a popular love song of the period (fig.29). Using a style that looked anonymous in its inclusion of mass-cultural processes and references and which

7. Mask, Grebo Ivory Coast
Wood, paint and vegetable
fibres
80 × 24 × 13
Musée national Picasso-
Paris

8. Picasso with an
installation of works
in his studio at 242
boulevard Raspail, Paris,
photographed in late 1912
or early 1913
Archives Olga Ruiz-
Picasso, courtesy
Fundación Almine y
Bernard Ruiz-Picasso para
el Arte, Madrid

was almost indistinguishable from Braque's, Picasso advanced his primitivist disdain for conventional notions of the fine arts and artistic authorship. At the same time, the poetically suggestive character of these paintings reveals a continuity with Picasso's symbolist phase.

In spring 1911 a group of young artists influenced by analytical cubism began to exhibit together, quickly transforming the style into a movement. To distance themselves from this unwelcome following, Picasso and Braque took their experimentations further. In 1912 they began to use a series of revolutionary materials and techniques that defied the limits of painting, such as *papiers collés* (pasted papers).[19] In his first extensive collage, *Still Life with Chair Caning* 1912, Picasso glued an illusionistic oilcloth onto a canvas shaped as a chair-seat, painted in the style of analytical cubism and framed by a sailor's rope (fig.30). The result blurs the line between artistic genres (painting and relief) as well as between reality and illusion.

That summer, while on holiday together, Picasso and Braque visited a flea market where Picasso bought an African mask (fig.7). Back in Paris, in autumn 1912 Picasso made his first planar construction, a cardboard guitar based on the structure of the mask and Braque's recent paper sculptures (which have not survived). He subsequently arranged *Guitar* to be photographed as a wall relief within ephemeral

9. Jean-Auguste-Dominique Ingres
Odalisque with Slave
1839–40
Oil paint on canvas
72.1 × 100.3
Harvard Art Museums,
Fogg Museum,
Cambridge, MA

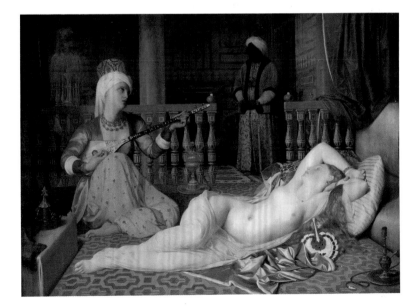

installations in his new Montparnasse apartment (fig.8).[20] The cardboard *Guitar* served as the template for the more robust *Guitar 1914* in sheet metal.[21] Both are made of component parts that can be easily copied and assembled.[22] The cardboard piece can also be easily disassembled, and this is how it was stored for more than a century.[23]

This phase of cubism, in which the creation of coherent representation rests on the mutual dependence of neighbouring elements, is called synthetic. Its apotheosis is *Woman in a Chemise in an Armchair* 1913–14 (fig.31), whose sensuality rests largely on the reference to established depictions of the female nude (fig.9).[24] Through the use of Ripolin (a commercial enamel-based paint), collaged materials and *papier collé*, cubism became increasingly decorative. Its character remained, however, highly experimental, as demonstrated by *Glass of Absinthe* 1914 (fig.32). This sculpture, originally made in wax, survives in six bronze casts, all differently decorated. Picasso originally used a modelling material to make planar shapes that, when assembled, create volume in the round. Then, he added readymade objects (metal absinthe spoons) into the bronzes.[25]

By the time the First World War began, cubism had evolved into a varied style rooted in the artisan crafts but also capable of incorporating tradition, often with tongue-in-cheek humour. *Portrait*

10. French and American Managers and the Horse. Costumes for *Parade* 1917 Unknown photographer Bibliothèque nationale, Paris

11. Olga Khlokhlova in a
chair 1918/19
© Cliché Daniel-Henry
Kahnweiler
© Leiris/Q.L Paris

of a Young Girl 1914 (fig.33) shows Picasso's virtuosity at imitating wallpaper in oil and his competitive dialogue not only with Braque, but also with Henri Matisse, whose *Portrait of Madame Matisse* 1913 he playfully referenced.[26] This example of so-called rococo cubism brings together the popular culture of cubism and the canons of bourgeois painting, in this case portraiture, poking fun at the middle-class emulation of aristocratic rites while reflecting the gentrification of the avant-garde.

The Great War and the Great Tradition

During the war, cubism came under public attack as a threat to French values.[27] Countering both the growing nationalism of the period and the evolution of cubism into a movement, Picasso began to draw in the style of Jean-Auguste-Dominique Ingres, the elegantly distortive nineteenth-century academician who had provided him with inspiration since 1905 (fig.34). Isolated in Paris after Braque's and Apollinaire's departures for the front, Kahnweiler's exile and Eva's death from illness, Picasso in 1917 accepted an invitation to produce sets and costumes for a Ballets Russes production, *Parade*, which took him to Italy for the first time (fig.10). The duality between *Parade*'s cubist decor and its classicising curtain revealed Picasso's defiance

12. Henri Matisse
Spanish Still Life 1910–11
Oil paint on canvas
89.5 × 116.3
State Hermitage Museum,
St Petersburg

of stylistic consistency, now informed by first-hand experience of the multifaceted character of the classical tradition (fig.35). While working on *Parade*, Picasso met his future wife, the Russian ballerina Olga Khokhlova, whom he married in summer 1918. Earlier that year, he painted her portrait in the style of Ingres (fig.36).[28] The starting point was a photograph for which Khokhlova posed in Picasso's studio (fig.11). In the painting Picasso distilled Khokhlova's likeness, while also leaving the canvas seemingly unfinished. Classicism functions here as a filter for present-tense experiences, in ways similar to a photographic negative from which the past emerges as a living, if frozen, creature.[29] The flatness of the portrait and the centrality of the patterned, abstracted armchair link this painting not only to Ingres's glamorous portraits of women but also to Matisse's richly decorative interiors (fig.12). In early 1918, Picasso and Matisse were shown together in the first exhibition of a long series that would foster and draw upon their friendship and rivalry.[30]

A short while afterwards, the Picassos moved into an apartment on rue La Boétie, an elegant street in the centre of Paris lined with art galleries; the gallery of Picasso's new dealer Paul Rosenberg was next door. Marriage, fatherhood (his son Paulo was born in 1921) and

the revenues from his theatrical collaborations dramatically changed Picasso's status. He and Olga began to participate in the Parisian social calendar, spending time in the company of aristocrats and international socialites. In 1923, they holidayed on the Côte d'Azur with Sara and Gerald Murphy, wealthy expatriate Americans who were at the centre of a vibrant social circle of artists and writers on the Riviera. *The Pipes of Pan* 1923 is a result of that modern Mediterranean experience (fig.37). This painting encapsulates Picasso's neoclassical ability to conflate past and present by condensing the entire span of Western culture. It simultaneously references ancient statues of virile heroes and twentieth-century androgynous ballet culture, as well as the Roman poet Ovid's *Metamorphoses* with its themes of creation and transformation, and the philosopher Friedrich Nietzsche's concept of the 'Apollonian' and the 'Dionysian' – the idea that artistic creation depends on a tension between two opposing forces.[31]

13. *Three Studies for a Guitar,* Sketchbook, Juan -les-Pins, Summer 1924
Ink on paper
31.5 × 23.5
Reproduced in lineblock in Honoré de Balzac, *The Unknown Masterpiece*, published by Ambroise Vollard, Paris 1931
Musée national Picasso-Paris

Interwar / Inter-styles: classicism, cubism, surrealism

The combination of classicism and cubism in *Parade* set the pattern for the coexistence of these styles in Picasso's work of the interwar years. In 1931 Vollard published a centenary edition of the novella *The Unknown Masterpiece* by Honoré de Balzac, with illustrations by Picasso. Among the reproductions were dot-and-line drawings that Picasso had made previously for his last ballet collaboration, *Mercure* 1924 (fig.13). Responding to Vollard's commission, Picasso also created a group of classical prints on the theme of Balzac's story of an artist's struggle and ultimate failure to represent reality (fig.14). Alternating near-abstraction with classicism in this manner, the book illustrations demonstrate Picasso's stylistic versatility and underline his independence from the art movements of the day.

Nonetheless, he did undoubtedly fall under the influence of surrealism, the leading cultural phenomenon of the interwar period, in the same way that surrealism was in turn deeply indebted to cubism. In 1924, the year in which he wrote the first surrealist manifesto, André Breton arranged the sale of *Les Demoiselles d'Avignon* and reproduced Picasso's large, grisaille sheet-metal *Guitar* 1924 in the first issue of the surrealists' journal *La Révolution surréaliste* (fig.15). This funereal sculpture looks back to the cubist constructions of

14. *Painter and Model Knitting* 1927
Etching
19.3 × 27.8 (plate)
From Honoré de Balzac, *The Unknown Masterpiece,* published by Ambroise Vollard, 1931
The Museum of Modern Art, New York

15. *Guitar* 1924
Painted sheet metal,
painted tin box, and iron
wire
111 × 63.5 × 26.6
Musée national
Picasso–Paris
Reproduced in Pierre
Reverdy, 'Le Rêveur
parmi les murailles', *La
Révolution surréaliste*, no.1,
December 1924, p.19

1912–14 that had been reproduced by Apollinaire in his journal *Les Soirées de Paris* (1912–14), and may represent Picasso's initial attempt to design a tomb for the poet, who had died prematurely in 1918.[32] *Guitar*'s evocation of both an opened-up corpse and the body of a woman experiencing *la petite mort* ('little death': the sensation of orgasm as brief loss of consciousness) connects it with Apollinaire's erotic poetry and the surrealists' celebration of sex as sacrifice. Another *Guitar*, a large collage of 1926, expounds the sadistic nature of the guitar–woman metaphor, revealing the central role of total eroticism for the surrealists (fig.39). *The Three Dancers* 1925, in which the classical motif of the Three Graces is represented in a primitivist style, shows Picasso's passage from the more composed mode of his 'ballet era' to the surrealist notion of 'convulsive beauty' (fig.38).

Picasso followed Breton's precept of *l'amour fou* (mad love) into practice, when in 1927 he began an ardent love affair with a seventeen-year-old he first met in the street, Marie-Thérèse Walter. She became the catalyst for his experimentations with completely

different styles. While holidaying in Cannes and Dinard during the two summers after they first met, Picasso filled sketchbooks with drawings that alternate the biomorphic forms of surrealism (in which abstract shapes evoke living beings) (fig.40), African-inspired assemblages and the geometry of cubism in an attempt to explore various sculptural alternatives for Apollinaire's tomb: modelled sculpture, assembled constructions and 'drawing in space'.[33]

In *Painter and Model* 1928, cubism, classicism and surrealism align to represent visually the intersection of reality and artistic fantasy (fig.41). The culmination of Picasso's (failed) interwar attempts to fulfil the Apollinaire commission is *Woman in the Garden* 1929–30, which merges surrealist organicism, cubist constructivism and the classical imagery of metamorphosis from human to vegetable (fig.43). Picasso welded the white painted iron himself. He had learnt the technique from his Barcelona friend Julio Gonzáles, a metal sculptor in charge of translating Picasso's earlier drawings for sculptural projects into three dimensions (fig.42). Gonzáles welded another, dark version of *Woman in a Garden* in bronze, which was placed outdoors at Boisgeloup, the country estate near Paris that Picasso bought in 1930.[34]

The deterioration of Picasso's marriage to Olga can be followed through a series of 'monstrous' paintings. In its hysterical perversion both of Breton's 'convulsive beauty' and of the odalisque theme dear to Ingres and Matisse, *Large Nude in a Red Armchair* 1929 signals Picasso's closeness with the surrealists Michel Leiris and Georges Bataille (fig.44). By contrast, the paintings inspired by Walter that Picasso began in December 1931, such as *Nude Woman in a Red Armchair* 1932, are replete with sensuality (see cover). Yet even these 'portraits' show Picasso's ambivalence at this time towards beauty (and by extension towards women and art). *Girl before a Mirror* 1932 merges the tradition of vanitas pictures with the motif of the split psyche cherished by the surrealists, reorienting the depiction of the myth of Narcissus made by the Italian baroque artist Caravaggio (fig.45).[35] The harlequin-patterned room that Walter inhabits indicates that the painting is also a commentary on Picasso's own identity as an artist then busy preparing his first retrospective and the first volume of his catalogue raisonné.[36]

In the spacious, converted stables of Boisgeloup, Picasso had found the right conditions to accomplish sculpture on a monumental

16. Front cover of
Minotaure, no.1, June 1933
Tate Library and Archives

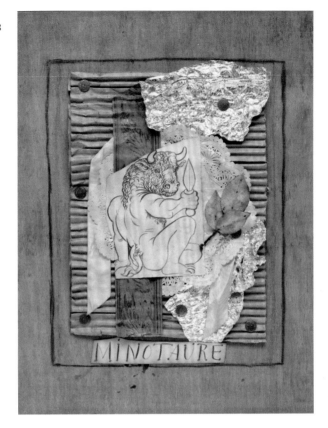

scale. Working at night by the light of oil lamps, he created modelled,
assembled and carved plasters inspired by Walter that recalled his
sculptural drawings and, again, looked to Matisse's example (fig.46).[37]
He began to incorporate found materials, first as armatures, then as
iconographical motifs.[38] He also used the casting quality of plaster to
imprint textures onto the wet material. Picasso did not exhibit or sell
the Boisgeloup plasters, but they became widely known through a
series of dramatic photographs taken by Brassaï that appeared in the
first issue of the surrealist publication *Minotaure* under the heading
'The Sculptor's Studio'.[39] The same title was given to a series of forty-
six etchings that Picasso made between March 1933 and March 1934
and later published within a group of prints known as the *Vollard Suite*,
a continuation of the aesthetic explorations begun in Vollard's earlier
commission for *The Unknown Masterpiece*.

Another section of the *Vollard Suite* is dedicated to the figure
of the Minotaur. Along with the collage cover design that Picasso
produced for *Minotaure*, this marks the beginning of his identification
with the mythological creature that is half-man, half-bull (fig.16). By
1935 the Minotaur had become Picasso's new alter ego. This was the
same year that he attended his last bullfight in Spain, Marie-Thérèse
Walter gave birth to their daughter Maya, and he separated from
Olga Khokhlova (forcing him to move out of Boisgeloup). Taking a
sabbatical from painting, Picasso devoted himself to writing surrealist
texts and to graphic work. The virtuoso etching *Minotauromachy*
1935 (created in the workshop of the printmaker Roger Lacourière)
is a personal reinterpretation of the Minotaur myth that presents the
creature, and Picasso, as both executioner and victim (fig.47).

The war years: Political and private conflicts
The outbreak of the Spanish Civil War between left-wing Republicans
and conservative Nationalists ushered in a period of overt political
engagement by Picasso. At the start of 1937 he accepted the
Republicans' commission to decorate their pavilion for that year's
Paris World's Fair. Picasso submitted a series of prints satirising
the Nationalists' leader General Franco and a few of his Boisgeloup
women sculptures cast in bronze and cement.[40] His main contribution,
however, was *Guernica*, a mural-size painting that took five intense
weeks to be realised (fig.48). Working in a new studio on rue des
Grands-Augustins,[41] his initial idea was to paint a large composition
on the theme of the painter and model, until the German Luftwaffe's
bombing of the Basque town of Guernica at the behest of Franco
prompted a return to the imagery of *Minotauromachy*. In the painting,
Picasso ditched mythological naturalism in favour of a narrative
influenced by newsreels that presented cubism, unmistakably, as the
style of anti-fascism. Embracing the immediacy of journalism, Picasso
reversed his tested method of abstracting present-time situations and
gave maximum intimate expression to universal emotions.

Weeping Woman 1937 (fig.49) is the culmination of a series of
head studies made alongside and following *Guernica*. At this point
Picasso was being fought over by two women, Marie-Thérese Walter
and a new mistress, Dora Maar, a photographer associated with the
surrealists who assisted his work on *Guernica* and documented it.

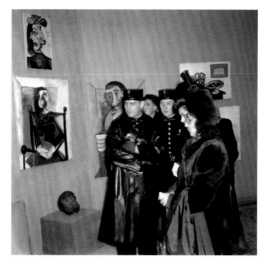

17. Policemen and women next to Picasso's *Death's Head* 1941 (cast in bronze by 1943) at the Salon d'automne (Salon de la Libération), Paris 1944 Photograph by Robert Doisneau

Weeping Woman, a small painting based on Maar's sophisticated appearance, is a private, domesticated and bourgeois version of the collective, public and popular anguish depicted in the large-scale *Guernica*. Both paintings bring together the expressive qualities of cubism and surrealism's penchant for metaphorical motifs – the dagger-like tongue of *Guernica*'s mother, the capsized boats as eyes overflowing with tears of *Weeping Woman* – demonstrating cubism's enduring expressive power despite its art deco drift following the style's success in the 1925 Paris World Fair.

With the outbreak of war in September 1939, Picasso moved to Royan, near Bordeaux, with Maar and his faithful secretary Jaime Sabartés.[42] In Royan, he filled eight sketchbooks with drawings of still lifes (in the Spanish tradition of the *memento mori*) and studies for large figure paintings.[43] Worried for the safety of his work, he returned to occupied Paris despite the fact that the Nazis had labelled him a 'degenerate' artist, and from 1942 lived in the Grands-Augustins studio. *The Serenade* 1942 conveys his confined existence there, substituting the domestic sensuality of the odalisque tradition with the claustrophobic discomfort of life during war (fig.50). Such difficulty did not prevent Picasso from making new modelled sculptures based on drawings, such as *Man with Ram* 1943 (fig.51), as well as surrealistic assemblages. In defiance of war proscriptions, he had many of the new works and his Boisgeloup plasters cast in bronze.[44]

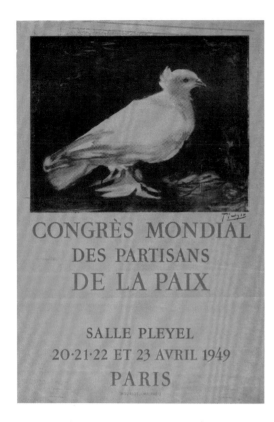

18. Poster for the World
Peace Conference,
Paris, 20–23 April 1949,
reproducing *Dove* 1949
Lithograph
59.7 x 40.3
The Museum of Modern
Art, New York

After the liberation of Paris in 1944, Picasso emerged as a resistant
and a hero, his wartime output celebrated in that year's Salon
d'automne (fig.17). He joined the French Communist party, making
his art's political leanings explicit by producing posters for peace
conferences (fig.18). He remained, however, deeply concerned too
with the depiction of intimate emotions. *The Charnel House* 1944–5,
his first major political work since *Guernica*, is based on a short
documentary film about a Spanish Republican family killed in their
kitchen, literally bringing home the horrors of concentration camps
(fig.52). The work also resonates with the tragic deaths during the
Occupation of Picasso's Jewish friends Max Jacob and Carl Einstein.
This intimate history painting has its footnote in the found-object
sculpture *Venus of the Gas* 1945, a gas burner and pipes that, in a
distortion of the Fascists' racist appropriation of European prehistory,
turns the image of the fertility goddess into one of annihilation (fig.53).

Post-war in the South: The Joy of Life

In 1943 Picasso met Françoise Gilot, a young painter forty years his junior. She became his mistress for the next nine years and the mother of two of his children, Claude (b.1947) and Paloma (b.1949). From 1946 the couple spent long periods in the South of France, where Picasso began experimenting with ceramics at the Madoura pottery workshop in Vallauris, a village between Antibes and Cannes. With the aid of master potters, he reinvented the ancient form of the vessels, taking inspiration from antiquity itself (fig.19). Working in the Antibes Antiquities Museum, he also painted a series of works on mythological subjects. *The Joy of Life* 1946, with Gilot at its centre, is a celebration of renewed energy after the devastation of the war (fig.54). It was also Picasso's homage to Matisse, who was long established on the Côte d'Azur, and whose painting *The Joy of Life* 1905–6 had reinterpreted the ancient pastoral theme for modernity.[45]

Picasso signed a new contract in 1947 with Kahnweiler, who saw the possibility to cast the artist's new sculptures in very limited bronze editions for sale.[46] In 1949, he converted an old perfume factory near his new home in Vallauris into a studio where, for the first time since Boisgeloup, he could set up a separate sculpture workshop. Domestic life and the presence of a dump near the studio inspired playful and inventive assemblages, such as the aerial *Little Girl Skipping Rope* 1950, in which plaster holds together found objects

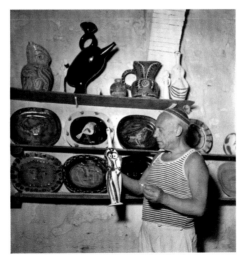

19. Picasso holding a Tanagra figurine, Madoura, Vallauris 1948
Photograph by Yves Manciet

whose original identities remain visible (fig.55). Inspired by Matisse's and Marc Chagall's decorations in nearby chapels, Picasso painted large panels on the theme of *The War* and *The Peace* for the disused chapel in Vallauris (1952), linking his family life in the South of France – glamorised by paparazzi – to the ancient tradition of the idyll.

'Late' Picasso

In 1953 Gilot left Picasso and moved to Paris with the children.[47] Jacqueline Roque, an employee at Madoura, became Picasso's new muse; they married in 1961, when she was twenty-seven and he was seventy-nine (fig.20). The wealthy couple, who featured frequently in the media, moved into a series of ever larger properties in the South, where Picasso could gather his vast collection of his own works and those of other artists (see fig.1). In 1954, while uncharacteristically working from a model, Picasso was influenced by Matisse's recent cut-outs to return to his childhood pastime of cutting paper silhouettes, which he now folded as designs for freestanding sculptures. These would be realised in iron by craftsmen in scrap metal workshops.[48] Picasso would then paint the sculptures, which he did with increasing playfulness (fig.58). From 1963, he allowed for the less private of these sculptures, and some of his 1920s projects for the Apollinaire monument, to be enlarged as public monuments.

Old age, the demise of many of the artists with whom he had entertained a life-long dialogue (Matisse died in 1954, Braque in 1963), the shift of the art world from Paris to New York and the triumph of abstraction all brought about Picasso's retreat into his work, and a more intense and more experimental approach to the past than ever. He dedicated his last twenty years to an almost obsessive return to specific old masters' works exploring the relationship between artist and model, and to this theme itself, now treated with daring eroticism, as part of 'his endeavour to resolve the eternal conflict between art and life, reality and illusion'.[49] Between 1954 and 1962 he painted fifteen variations on Eugène Delacroix's *Women of Algiers in their Apartment* 1834, forty-five on Diego Velázquez's *Las Meninas* 1656 (fig.56) and twenty-seven on Edouard Manet's *Le Déjeuner sur l'herbe* 1863.[50] These 'studies' were sustained by numerous drawings and prints, and sometimes sculptures. The artist's growing sense of intimacy with the masters – to the point of exuberant camaraderie

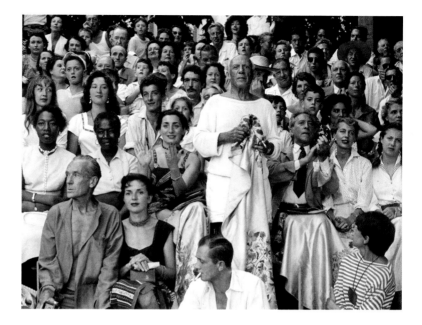

20. Picasso, with Jacqueline Roque at his right, attending the bullfight put on in his honour, Vallauris 1955
Photograph by Edward Quinn
Edward Quinn Archives, Switzerland

– is epitomised by *Woman Pissing* 1965, a cartoon-like pastiche combining elements of the Dutch master Rembrandt van Rijn and also of ancient vase illustrations (fig.59).

Picasso experimented with materials and techniques until the end, pushing artistic genres and media to their limits and beyond. He innovated the printing techniques of lithography and linocut (with, respectively, master printmakers François Mourlot and Hidalgo Arnéra), inventing the process of one-block printing for colour linocuts (fig.57). Two titanic series of etchings, the suites *347* made in 1968 and *156* from 1970–2, named after the large number of prints produced at a unique speed with the printers Aldo and Piero Crommelynck, summarise Picasso's career. They reunite his pantheon of artists and motifs in an orgy of styles and periods, presenting the power of art, Picasso's in particular, to transform life into spectacle.

Picasso died in his property of Mougins, Cannes, on 8 April 1973, at the age of ninety-one. He is buried in his country estate of Vauvenargues, Aix-en-Provence, under a bronze cast of his Boisgeloup sculpture *Woman with Vase* 1933. He remains one of the most popular artists in history.

21. *Academic Study of a*
Torso, Seen from the Back
1893–4 (after Charles Bargue,
Cours de dessin, 1868, pl.56)
Charcoal on paper
49 × 31.5
Musée national Picasso-
Paris

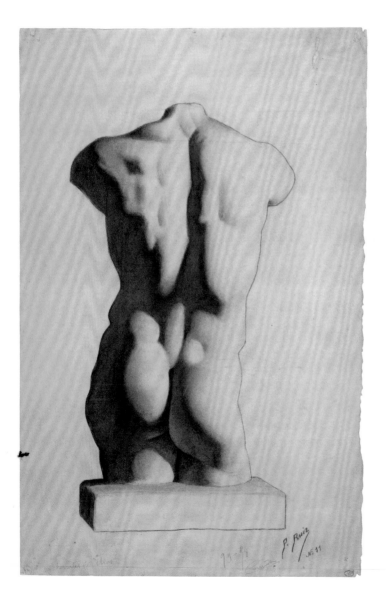

22. *The Moulin de la Galette* 1900
Oil paint on canvas
88.2 × 115.5
Solomon R. Guggenheim
Museum, New York

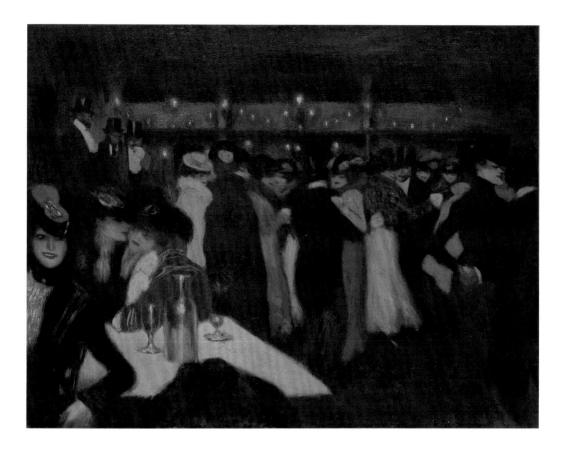

23. *Self-Portrait* 1901
Oil paint on canvas
81 × 60
Musée national Picasso-
Paris

24. *La Vie* 1903
Oil paint on canvas
197 × 127. 3
Cleveland Museum of Art.
Gift of the Hanna Fund
1945.24

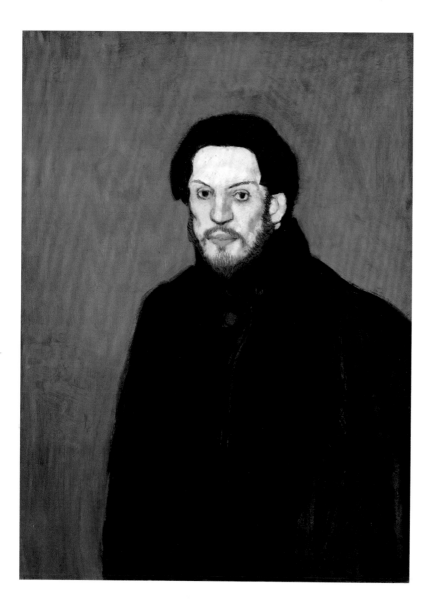

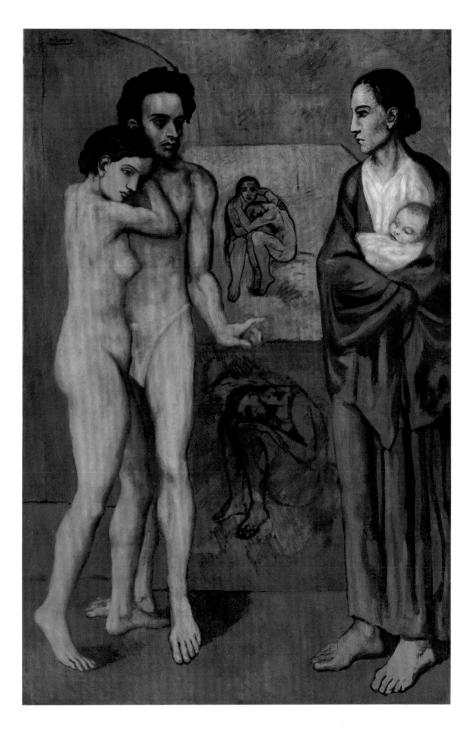

25. *Family of
Saltimbanques* 1905
Oil paint on canvas
212.8 × 229.6
National Gallery of Art,
Washington, DC

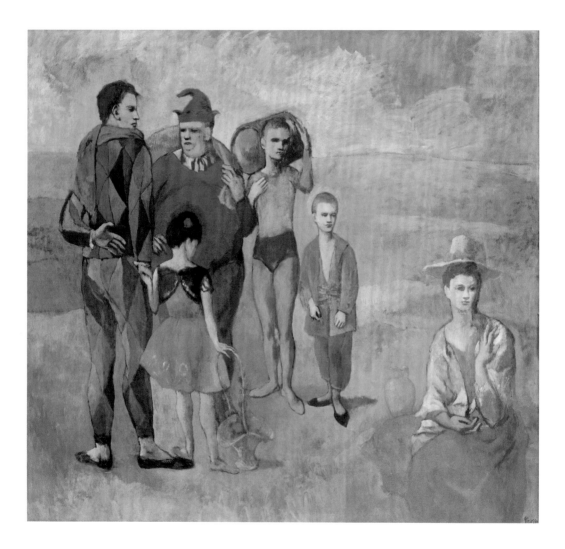

26. *Les Demoiselles
d'Avignon* 1907
Oil paint on canvas
243.9 × 233.7
The Museum of Modern
Art, New York

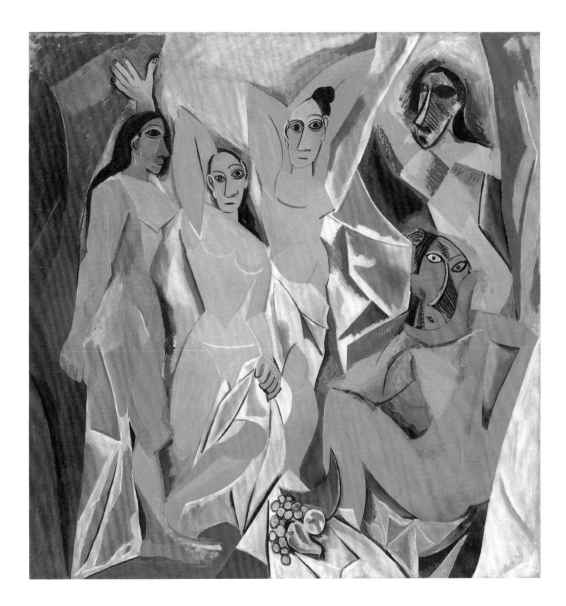

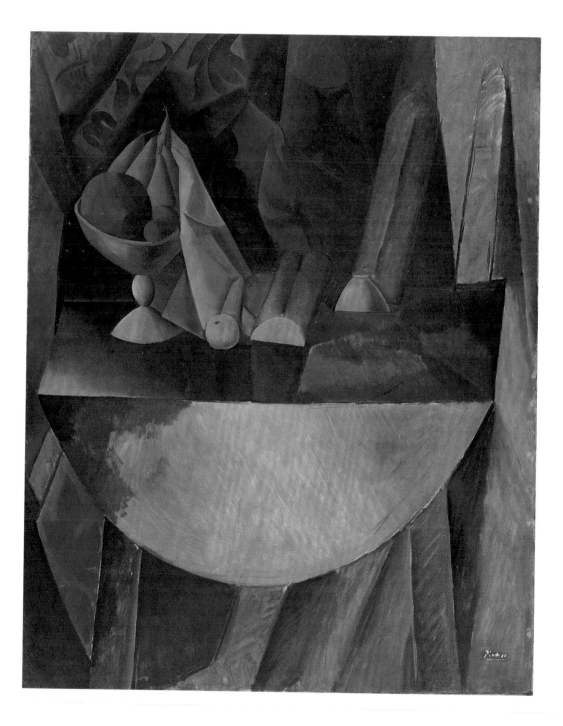

27. *Bread and Fruit Dish on a Table* 1908–9
Oil paint on canvas
164 × 132.5
Kunstmuseum Basel

28. *Seated Nude* 1909–10
Oil paint on canvas
92.1 × 73
Tate

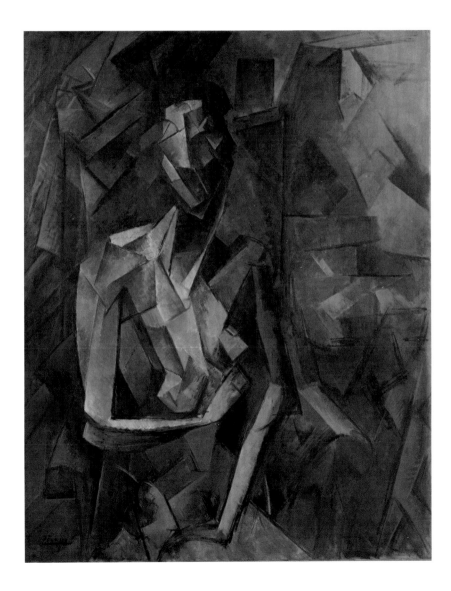

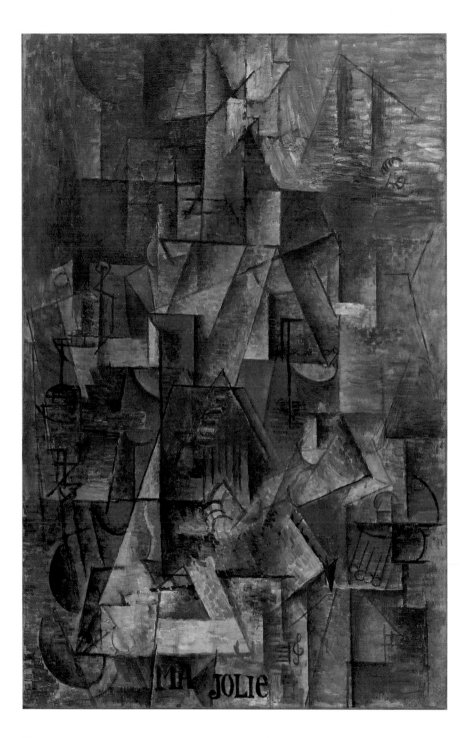

29. *'Ma Jolie' ('My Pretty Girl'), Woman with a Zither or Guitar)* 1911–12
Oil paint on canvas
100 × 64.5
The Museum of Modern Art, New York

30. *Still Life with Chair-caning* 1912
Oil paint, oilcloth and paper on canvas framed with cord
27 × 35
Musée national Picasso-Paris

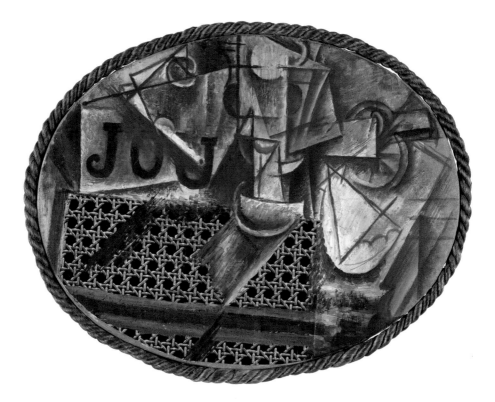

31. *Woman in a Chemise in
an Armchair* 1913–14
Oil paint on canvas
149.9 × 99.4
The Metropolitan Museum
of Art, New York

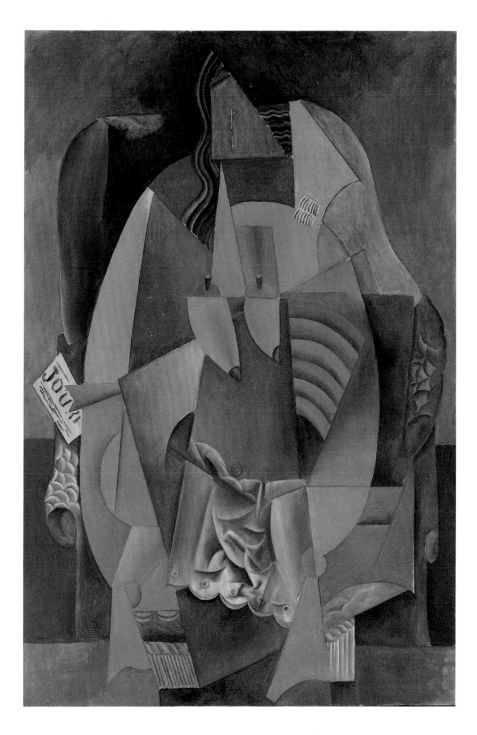

32. *Glass of Absinthe* 1914
Painted bronze and
perforated tin absinthe
spoon
21.6 × 16.4 × 8.5
The Museum of Modern
Art, New York

33. *Portrait of a Young Girl*
1914
Oil paint on canvas
130 × 96.5
Centre Pompidou, Musée
national d'art moderne,
Paris

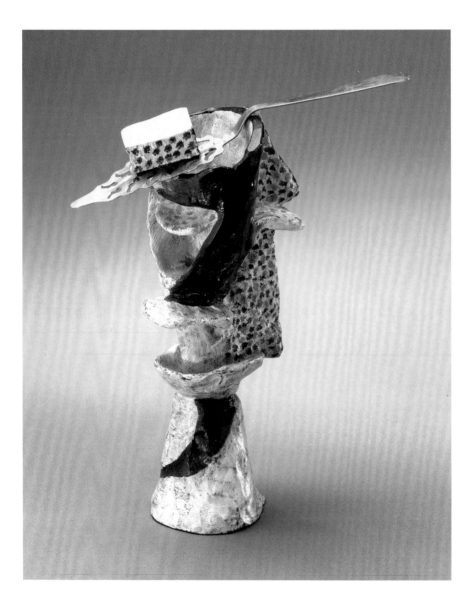

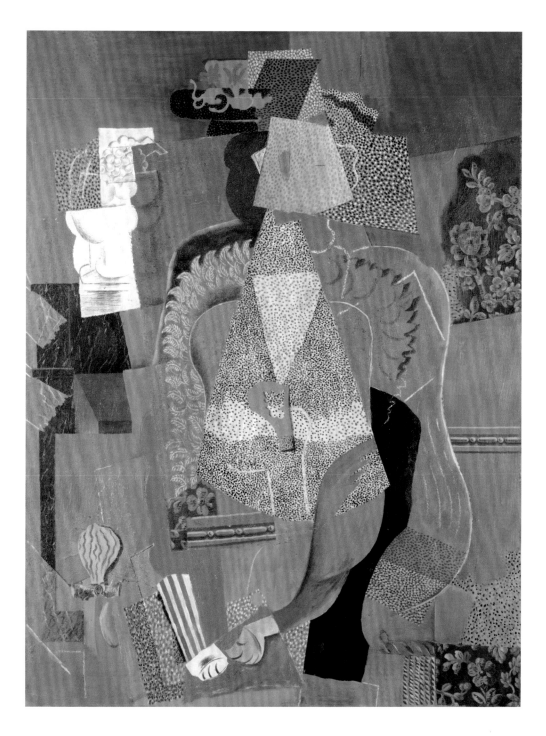

34. *Portrait of Ambroise Vollard* 1915
Graphite on paper
46.7 × 32
The Metropolitan Museum
of Art, New York

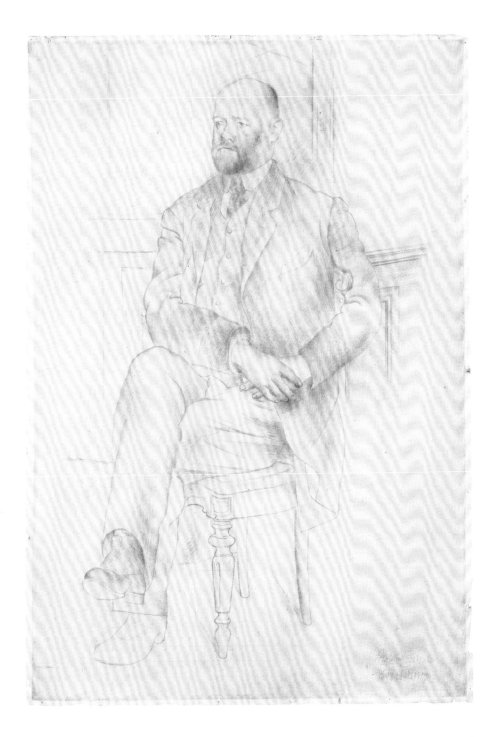

35. Drop curtain for *Parade*
1917
Glue-paint on canvas
1640 × 1050
Centre Pompidou, Musée
national d'art moderne,
Paris

36. *Portrait of Olga in an
Armchair* 1918
Oil paint on canvas
130 × 88.8
Musée national
Picasso-Paris

37. *The Pipes of Pan* 1923
Oil paint on canvas
205 × 174
Musée national
Picasso-Paris

38. *The Three Dancers*
1925
Oil paint on canvas
215.3 × 142.2
Tate

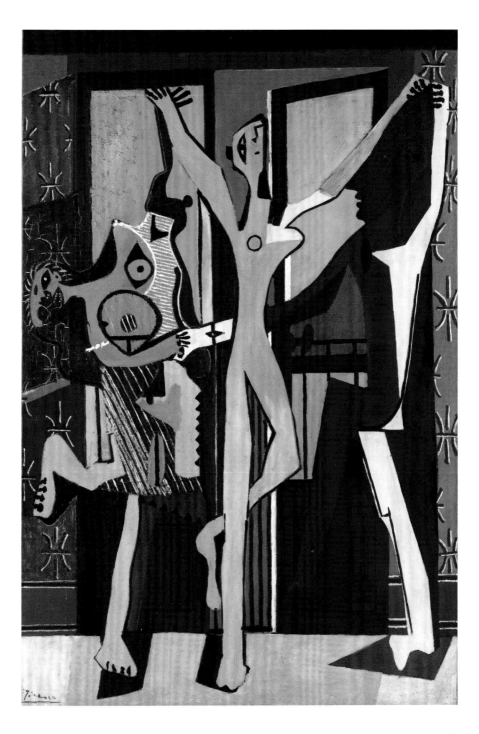

39. *Guitar* 1926
Relief-painting, canvas,
wood, rope, nails and
tacks on painted wood
130 × 96.5
Musée national
Picasso-Paris

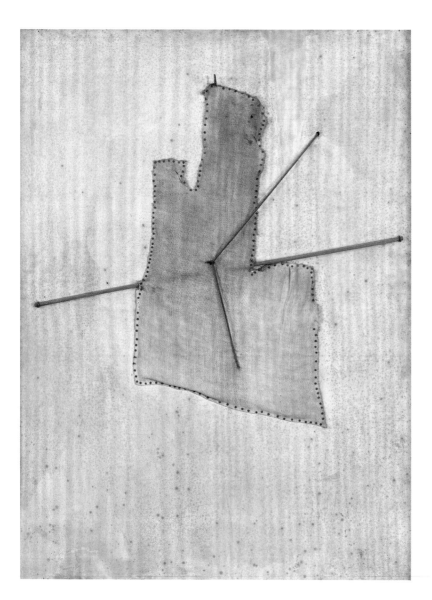

40. From Sketchbook 11,
Cannes, 11–24 September
1927
Graphite pencil on paper
30.3 × 23
Musée national Picasso-
Paris

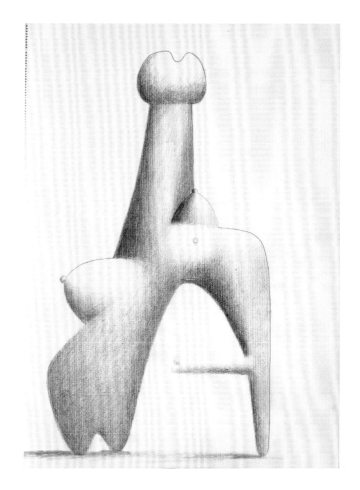

41. *Painter and Model* 1928
Oil paint on canvas
129.8 × 163
The Museum of Modern
Art, New York

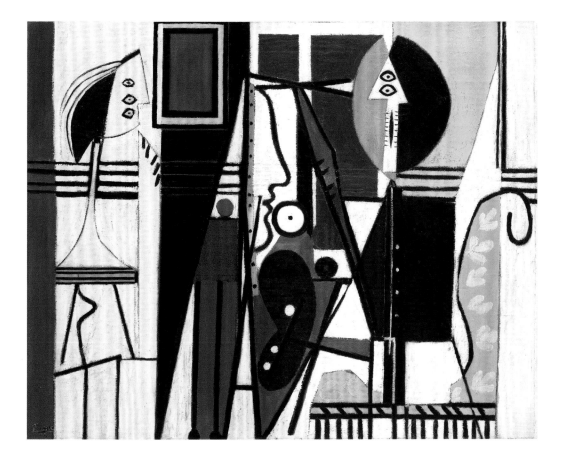

42. *Figure: Project for a Monument to Guillaume Apollinaire* 1928
Iron wire and iron sheet
50 × 18.5 × 40.8
Musée national Picasso-Paris

43. *Woman in a Garden*
1929–30
Welded iron painted white
106 × 117 × 85
Musée national Picasso-Paris

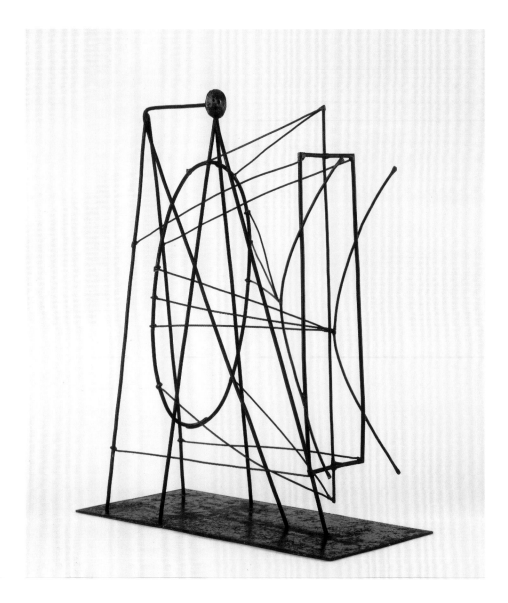

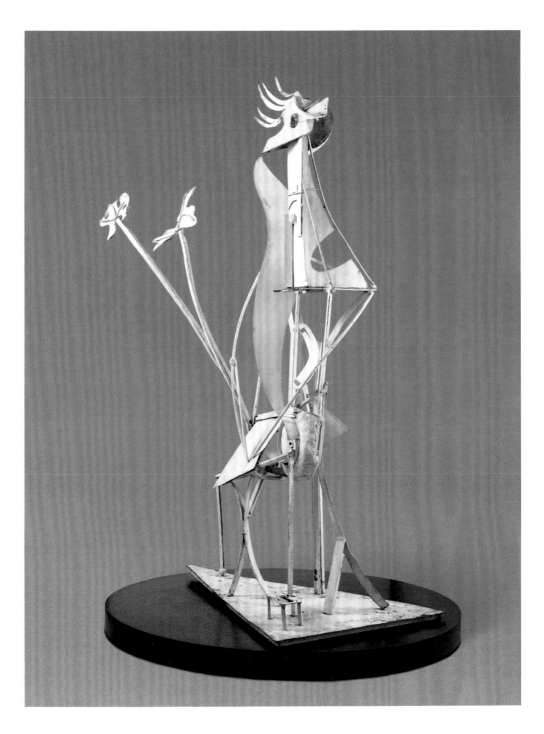

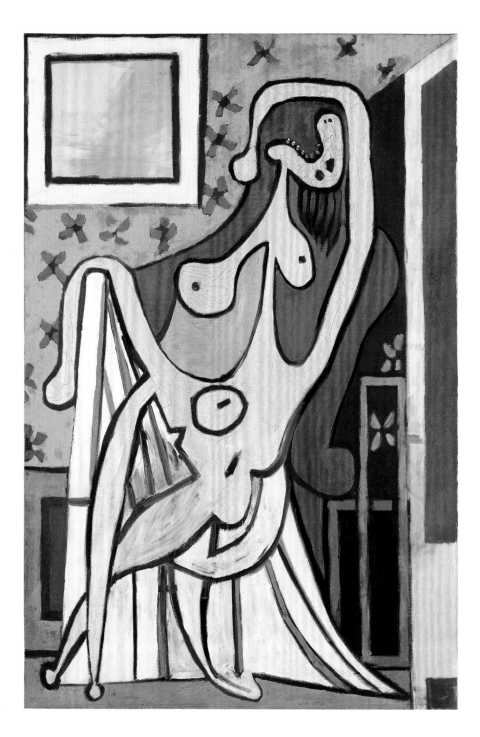

44. *Large Nude in a Red Armchair* 1929
Oil paint on canvas
195 × 129
Musée national Picasso-Paris

45. *Girl before a Mirror* 1932
Oil paint on canvas
162.3 × 130.2
The Museum of Modern Art, New York

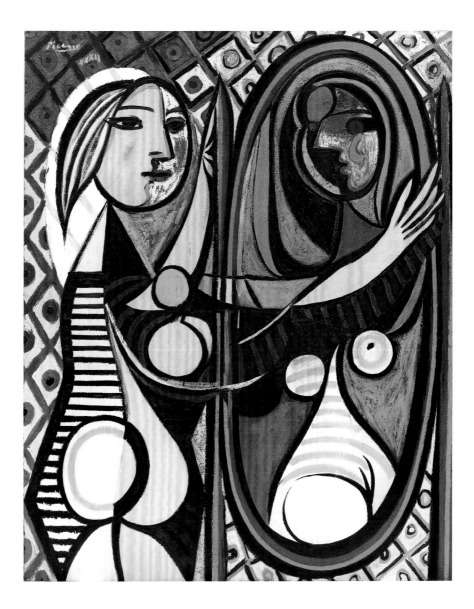

46. Interior of Picasso's
sculpture studio at
Boisgeloup, c.1932
Unknown photographer
Archives Olga Ruiz-
Picasso, courtesy of FABA

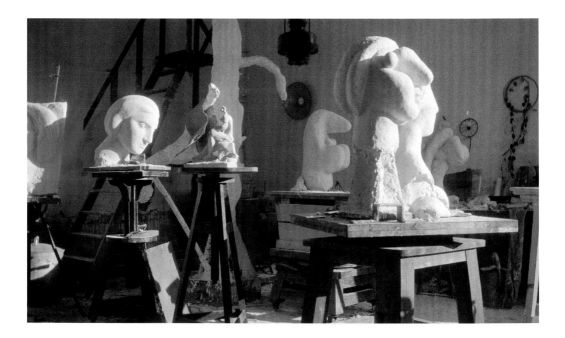

47. *Minotauromachy*
(state VII) 1935
Etching and engraving
on paper
49.8 × 69.3
The Museum of Modern
Art, New York

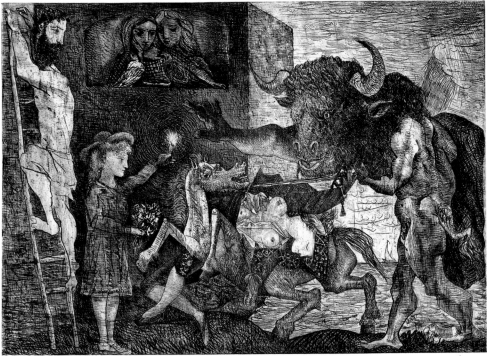

48. *Guernica* 1937
Oil paint on canvas
349.3 × 776.6
Museo Nacional Centro de
Arte Reina Sofía, Madrid

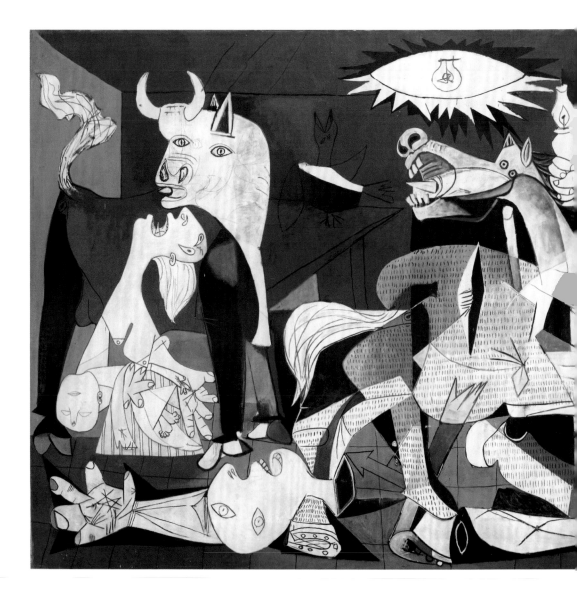

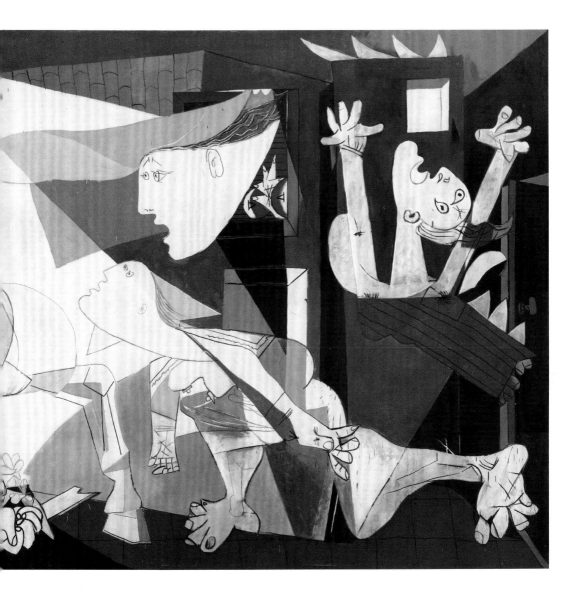

49. *Weeping Woman* 1937
Oil paint on canvas
59.7 × 48.9
Tate

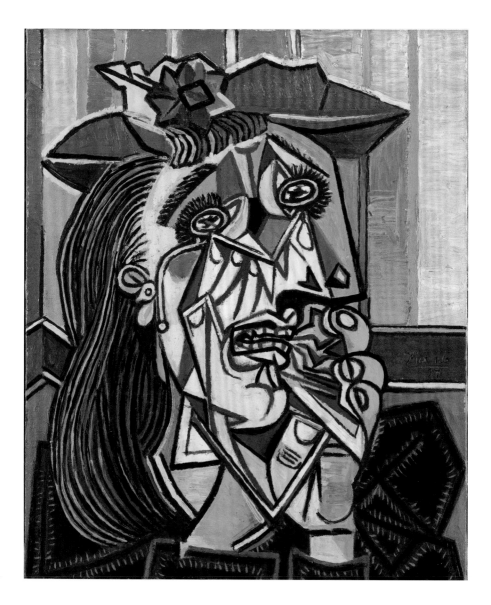

50. *The Serenade* 1942
Oil paint on canvas
195 × 265
Centre Pompidou, Musée
national d'art moderne,
Paris

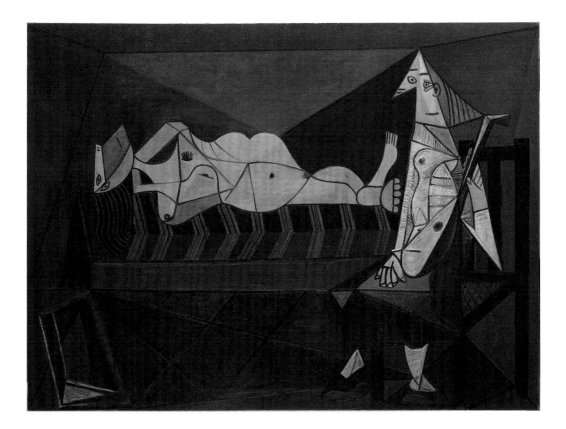

51. *Man with Ram* 1943
Patinated Roman cast
209 × 78 × 75
Museo Nacional Centro de
Arte Reina Sofía, Madrid

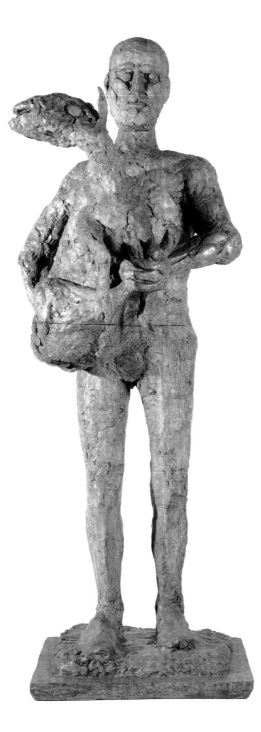

52. *The Charnel House*
1944–5
Oil paint and charcoal
on canvas
199.8 × 250.1
The Museum of Modern
Art, New York

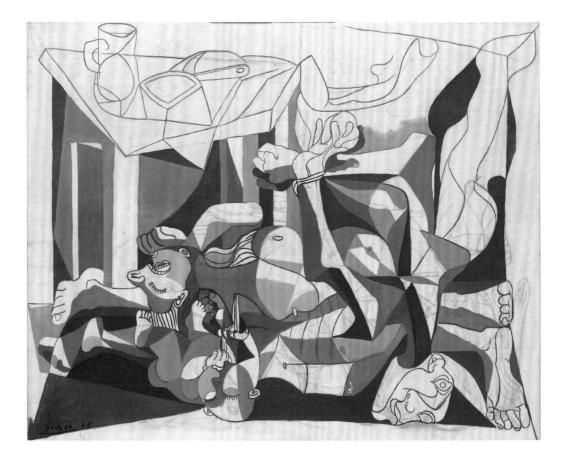

53. *Venus of the Gas* 1945
Iron gas burner and pipe
from a gas stove
25 × 9 × 4
Private collection

54. *The Joy of Life* 1946
Ripolin on fibrocement
120 × 250
Musée Picasso, Antibes

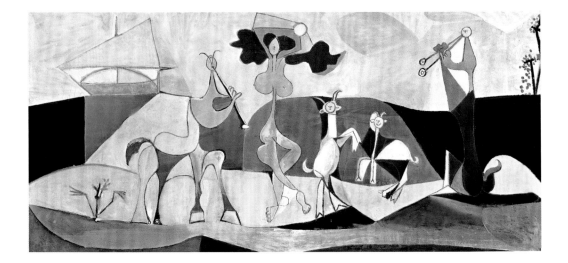

55. *Little Girl Skipping
Rope* 1950
Basket, cake pans, shoes,
wood, iron, ceramic
elements and plaster
152 × 6 × 66
Musée national Picasso-
Paris

56. *Las Meninas* 1957
(After Diego Velázquez)
Oil paint on canvas
194 × 260
Museu Picasso, Barcelona

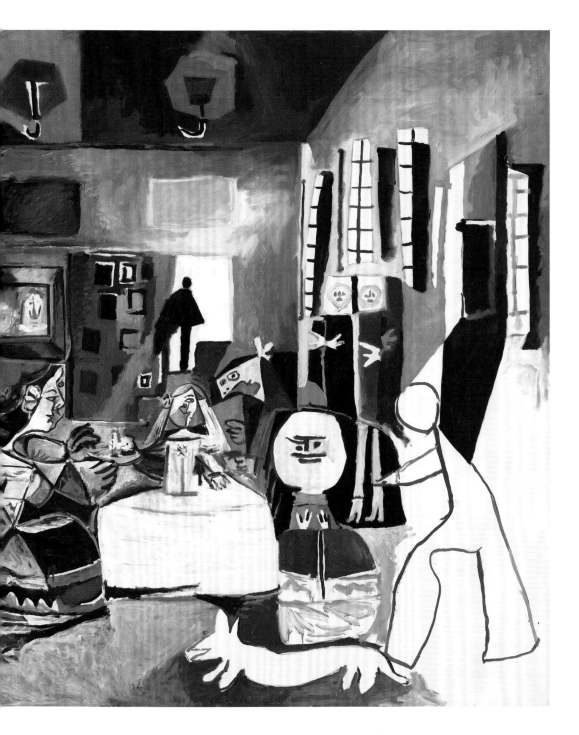

57. *Still Life with Glass under the Lamp* 1962
printed by Arnéra, Vallauris
Linoleum cut on paper
53 × 64
The Museum of Modern Art, New York

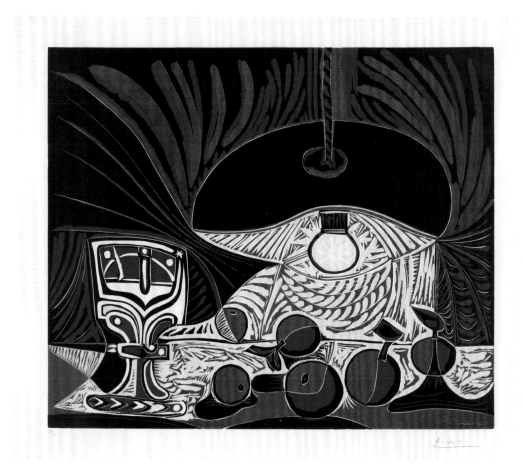

58. *Head of a Woman* 1962
Painted sheet metal and
iron wire
32 × 24 × 16
Musée national Picasso-
Paris

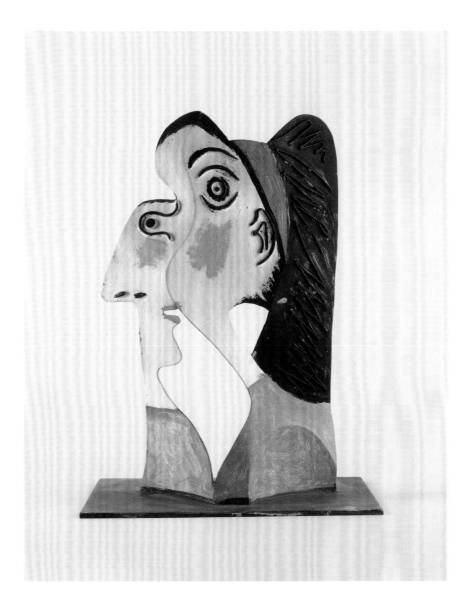

59. *Woman Pissing* 1965
Oil paint on canvas
194.8 × 96.5
Centre Pompidou, Musée
national d'art moderne,
Paris

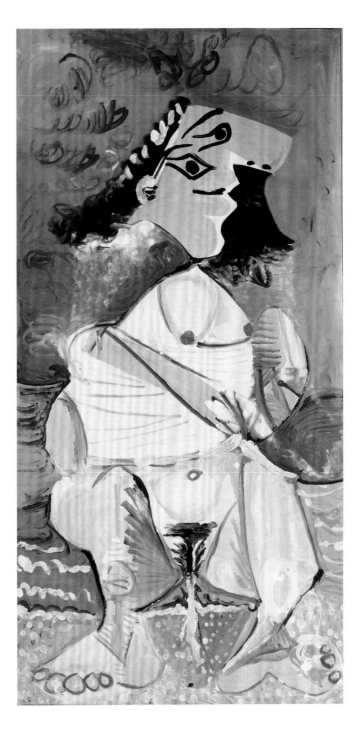

60. *Ecce Homo, after Rembrandt* from *Suite 156,* 1970
Aquatint, etching, scraping and drypoint on paper
49.5×41.2 (plate)
Museu Picasso, Barcelona

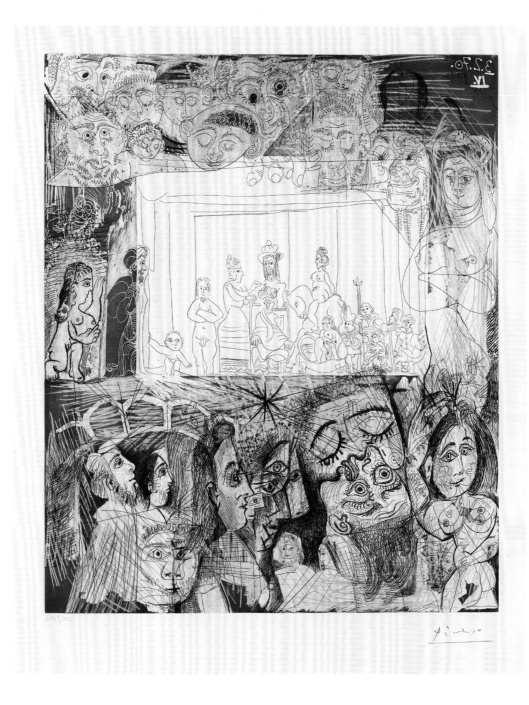

Notes

1. Picasso to Christian Zervos (1935), in Christian Zervos, 'Conversation avec Picasso', *Cahiers d'Art*, vol.10, nos.7–10, 1936, special issue 'Picasso, 1930–1935', p.176.
2. Roland Penrose, *Picasso: His Life and Work* (1958), Berkeley, California 1981, p.13.
3. Natasha Elena Staller, *A Sum of Destructions: Picasso's Cultures and the Creation of Cubism*, London and New Haven 2001, pp.89–90.
4. Elizabeth Cowling, *Picasso: Style and Meaning*, London and New York 2002, pp.35–57.
5. *Science and Charity* 1897, Museo Picasso, Barcelona.
6. Pierre-Auguste Renoir, *Dance at Le Moulin de la Galette* 1876, Musée d'Orsay, Paris. Cowling 2002, pp.73–4.
7. Marylin McCully, 'Picasso's Artistic Practice in 1901', in *Becoming Picasso*, exh. cat., Courtauld Gallery, London 2013, pp.37–59.
8. John Richardson, *A Life of Picasso*. Vol.1: *1881–1906*, New York 1994, pp.213, 233–49.
9. Fernande Olivier, *Picasso et ses amis*, Paris 1933, pp.354–5.
10. *Self-Portrait with a Palette* 1906, Philadelphia Museum of Art.
11. Silvia Loreti, 'The Affair of the Statuettes Re-Examined: Picasso and Apollinaire's Role in the Famed Louvre Thefts', in Noah Charney (ed.), *Art & Crime: Exploring the Dark Side of the Art World*, Santa Barbara 2009, pp.52–64.
12. For example, Cezanne's *Bathers* c.1894–1905, National Gallery, London.
13. Michael C. FitzGerald, *Picasso and the Creation of the Market for Twentieth-Century Art*, Los Angeles and London 1995, pp.15–46.
14. William Rubin (ed.), *Picasso and Braque: Pioneering Cubism*, exh. cat., The Museum of Modern Art, New York 1989, pp.354–5.
15. William Rubin, 'From Narrative to "Iconic" in Picasso: The Buried Allegory in *Bread and Fruit Dish on a Table* and the Role of the *Demoiselles d'Avignon*', *Art Bulletin*, vol.65, no.4, December 1983, pp.615–49.

16. Valerie J. Fletcher, 'Process and Technique in Picasso's *Head of a Woman (Fernande)*', in Jeffrey Weiss, Valerie J. Fletcher and Kathryn A. Tuma, *Picasso: The Cubist Portraits of Fernande Olivier*, exh. cat., National Gallery of Art, Washington DC 2003, pp.166–91.
17. *Head of a Woman (Fernande)* 1909, Tate, on long term loan from a private collection.
18. Daniel-Henry Kahnweiler, *The Rise of Cubism* (1920), New York 1949.
19. For a revised chronology of Braque's and Picasso's development of, respectively, pasted wallpaper and pasted newspaper, see Anne Umland, 'Braque's Faux Bois', in Emily Braun and Rebecca Rabinow (eds.), *Cubism: The Leonard A. Lauder Collection*, exh. cat., The Metropolitan Museum of Art, New York 2014, pp.97–105.
20. These photographs were staged, if not directly taken by Picasso himself: Blair Hartzell, 'Guitar, 1912', in Anne Umland, Blair Hartzell and Scott Gerson (eds.), *Picasso: The Making of Cubism 1912–14*, Chapter 3.4, and note 16, and Chapter 3.15, ebook, The Museum of Modern Art, New York 2014.
21. *Guitar* 1914, The Museum of Modern Art, New York.
22. As remarked by André Salmon as early as 1914. See Hartzell, 'Guitar, 1914', in Umland, Hartzell and Gerson 2014, Chapter 15.3–4 and note 9 (Chapter 15.7–8).
23. Christine Poggi, 'Picasso's First Constructed Sculpture: A Tale of Two Guitars', *Art Bulletin*, vol.94, no.2, June 2012, pp.274–98.
24. Cowling 2002, pp.263–6.
25. Lynda Zycherman, 'Making Picasso's *Glass of Absinthe* in Wax', *Inside/Out: A MoMA/MoMA PS1 Blog*, 16 December 2015, accessed August 2017.
26. Isabelle Monod-Fontaine, in *Matisse/Picasso*, exh. cat., Tate Modern, London 2002, p.97.
27. Christopher Green, *Cubism and its Enemies: Modern Movements and Reactions in French Art, 1916–1928*, New Haven and London 1987.

28. Jean-Auguste-Dominique Ingres, *Portrait of Madame Devauçay* 1807, Musée Condé, Chantilly.
29. For contrasting interpretations of the role of photography in Picasso's neoclassicism, see Rosalind Krauss, 'Picasso/Pastiche', in *The Picasso Papers*, London 1998, pp.89–210 and Cowling 2002, pp.292–3, 323–7.
30. *Matisse–Picasso*, Galerie Paul Guillaume, Paris, 23 January–15 February 1918.
31. Silvia Loreti, 'Diving Deep into a Mediterranean Affair: *The Pipes of Pan*, Nature and Culture', in Olivier Berggruen and Anunciata von Liechtenstein (eds.), *Picasso: Between Cubism and Classicism, 1915–1925*, exh. cat., Scuderie del Quirinale, Rome 2017, pp.89–97.
32. The 1912 cardboard *Guitar* was first reproduced in *Les Soirées de Paris*, no.18, 15 November 1913. For the 1924 *Guitar* in relation to the Apollinaire monument, see Cowling 2002, p.354.
33. Sketchbooks Paris–Cannes 1927 and no.1044, Dinard summer 1929, in Brigitte Léal, *Carnets: Catalogue des dessins*, vol.1, Paris 1996.
34. *Woman in a Garden* 1931–2, Museo Nacional Centro de Arte Reina Sofia, Madrid.
35. Caravaggio, *Narcissus* 1597–9, Galleria nazionale d'arte antica, Rome.
36. *Picasso*, Galeries Georges Petit, Paris, 16 June–30 July and Kunsthaus Zürich, 11 September–13 November 1932. See also Christian Zervos, *Pablo Picasso*. Vol.I: *Oeuvres de 1895 à 1906*, Paris 1932.
37. See Henri Matisse, *Jeannette (I–V)* 1910–16.
38. See *Head of a Warrior* 1933, The Museum of Modern Art, New York.
39. Brassaï's photographs (Boisgeloup, December 1932) were reproduced in André Breton, 'Picasso dans son élément', *Minotaure*, no.1, June 1933, pp.15–29.
40. *Dream and Lie of Franco* 1937, eighteen etchings and aquatints.
41. The new studio was in the very building on the Left Bank featured in Balzac's *The Unknown Masterpiece*.

42. Picasso's secretary Jaime Sabartés was a friend from the Barcelona years who had lived with Picasso since his separation from Olga.
43. *Woman Dressing her Hair* 1940, The Museum of Modern Art, New York.
44. Henri Matisse, *The Joy of Life* 1905–6, The Barnes Foundation, Philadelphia.
45. In 1949, Kahnweiler published the first book on Picasso sculpture, with photographs by Brassaï and Maar.
46. See Clare Finn, 'Picasso's Casting in Bronze during World War II', 'Picasso Sculptures', Conference Proceedings, Musée national Picasso-Paris, 25 March 2016. https://picasso-sculptures. fr/wp-content/uploads/2017/04/ Clare-Finn_Picasso%E2%80%99s-casting-in-bronze-during-World-War-II.pdf.
47. Gilot's memoirs of their time together provide an important document of Picasso's artistic practice. Françoise Gilot and Carlton Lake, *Life with Picasso*, New York 1964.
48. Diana Widmaier Picasso, 'Pablo Picasso's Sheet-Metal Sculptures, Vallauris 1954–1965', in Christoph Grunenberg (ed.), *Sylvette, Sylvette, Sylvette: Picasso and the Model*, Kunsthalle Bremen 2014, pp.160–97.
49. Marie-Laure Bernadac, 'Picasso 1953–1972: Painting as Model', in *Late Picasso: Paintings, Sculptures, Drawings, Prints, 1953–1972*, exh. cat., Tate Gallery, London 1988, pp.49–94.
50. Eugène Delacroix, *Women of Algiers in their Apartment* 1834, Musée du Louvre, Paris; Diego Velázquez, *Las Meninas* 1656, Museo del Prado, Madrid; Edouard Manet, *Le Déjeuner sur l'herbe* 1863, Musée d'Orsay, Paris.

Index

First published 2018 by order of the Tate Trustees
by Tate Publishing, a division of Tate Enterprises Ltd,
Millbank, London SW1P 4RG
www.tate.org.uk/publishing

© Tate Enterprises Ltd 2018
All works by Pablo Picasso © Succession Picasso /
DACS, London 2018

All rights reserved. No part of this book may be
reprinted or reproduced or utilised in any form or
by any electronic, mechanical or other means now
known or hereafter invented, including photocopying
and recording, or in any information storage or
retrieval system, without permission in writing
from the publishers or a licence from the Copyright
Licensing Agency Ltd, www.cla.co.uk

A catalogue record for this book is available from the
British Library
ISBN 978 1 84976 584 8

Distributed in the United States and Canada by
ABRAMS, New York

Library of Congress Control Number applied for

Designed by Anne Odling Smee, O-SB Design
Layout by Caroline Johnston
Colour reproduction by DL Imaging Ltd, London
Printed by Graphicorn Srl, Italy

Cover: *Nude in a Red Armchair* 1932, oil paint on
canvas 129.9 × 97.2. Tate. Purchased 1953

Frontispiece: Interior of Picasso's sculpture studio at
Boisgeloup, c.1932 (detail, see fig.46)

Measurements of artworks are given in centimetres,
height before width, before depth.

MIX
Paper from
responsible sources
FSC www.fsc.org FSC® C013123

Credits

References are to figure numbers.

Copyright

All artwork by Pablo Picasso © Succession
Picasso / DACS, London 2018

Georges Braque © ADAGP, Paris and DACS,
London 2018 6

© gal. Kahnweiler / Leiris, Paris 11

Henri Matisse © Succession H. Matisse / DACS
2018 12

© edwardquinn.com 20

Photography

© Archives Olga Ruiz-Picasso, Fundación Almine
y Bernard Ruiz-Picasso para el Arte.
Photographer unknown, all rights reserved
frontispiece, 8, 46

© Bibliothèque nationale, Paris 10

Photo © Centre Pompidou, MNAM-CCI, Dist.
RMN-Grand Palais / image Centre Pompidou,
MNAM-CCI 59

Photo © Centre Pompidou, MNAM-CCI, Dist.
RMN-Grand Palais / Christian Bahier / Philippe
Migeat 35; / Georges Meguerditchian 50; / Jean-
Claude Planche 33

© The Cleveland Museum of Art 24

Photo by Robert DOISNEAU/Gamma-Rapho via
Getty Images 17

Imaging Department © President and Fellows of
Harvard College 9

Photo by Daniel-Henry Kahnweiler © gal.
Kahnweiler / Leiris, Paris 11

Kunstmuseum Basel, Martin P. Bühler 5, 27

© Yves Manciet/Gamma-Rapho 19

© 2017. Image copyright The Metropolitan
Museum of Art / Art Resource / Scala, Florence
31, 34

Musée Picasso, Antibes, France / Bridgeman
Images 54

© Muséo nacional Centro de arte Reina Sofía,
Madrid 48, 51

© Museu Picasso, Barcelona / Gassul Fotografia
S.L. 56, 60; / Mario Clapés Mor 2

© 2017. Digital image, The Museum of Modern
Art, New York / Scala, Florence 14, 18, 26, 29, 32,
41, 45, 47, 52, 57

© National Gallery of Art, Washington / NGA
Images 25

© Arnold Newman / Liaison Agency / Getty
Images 1

Photo Edward Quinn 20

© RMN / Frank Raux 53

Photo © RMN-Grand Palais (musée d'Archéologie
nationale) / Franck Raux 4

Photo © RMN-Grand Palais (Musée national
Picasso-Paris) / Jean-Gilles Berizzi 13, 37, 39;
/ Adrien Didierjean 55; / Adrien Didierjean /
Mathieu Rabeau 43; / Béatrice Hatala 7, 21, 40,
42, 58; / Mathieu Rabeau 23, 30, 36, 44

Rupf Foundation, Bern, Switzerland / Bridgeman
Images 6

Solomon R. Guggenheim Museum, New
York. Thannhauser Collection, Gift, Justin K.
Thannhauser, 1978 22

Photograph © The State Hermitage Museum.
Photo by Yuri Molodkovets 12

© Tate, 2018 front cover, 28, 38, 49; / Samuel Cole
16; / Rod Tidnam 15